GREAT BIG BOOK ABOUT
THE PIPE ORGAN

打開管風琴的祕密

文‧圖／西妮雅‧博尼希

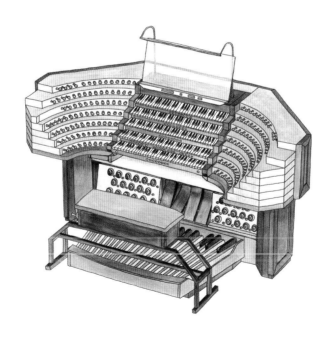

前言
讓我們愛上管風琴

簡文彬／衛武營國家藝術文化中心藝術總監

管風琴是人類有史以來設計過最複雜的樂器之一，所以被稱為樂器之王。在歐洲，管風琴一直是與大教堂結合在一起。只有宏偉的大教堂，才能容納得下管風琴巨大的音管，再加上其教堂獨特的聲響空間，也才能創造出震撼人心的音色。衛武營是亞洲最大的單一屋頂綜合表演藝術中心，同時擁有亞洲最大的管風琴。即使衛武營不是教堂，一樣具備能夠容納管風琴的巨大空間，將其安置在葡萄園式音樂廳，創造出無以倫比的絕佳音色。

這本繪本的出版，是希望能透過更輕鬆易解的方式，讓大人與小朋友都可以理解管風琴的設計，以及運作的原理。我一直認為，音樂不單純只是一種藝術享受，在音樂的背後所牽涉到，還有科學、文化、社會與歷史。管風琴的出現，恰好是西方近代科學與文化的結晶。我們都知道，巴赫在萊比錫的聖多瑪教堂擔任管風琴師與合唱團指揮，他甚至為管風琴寫了大家熟知的名曲，例如《D小調觸技曲與賦格》。當然，我們在生活中可以聽到很多管風琴的音樂，讀到與管風琴有關的故事，但卻很少有機會理解這項樂器的製作與設計。如今，大家不但有機會在衛武營音樂廳親眼目睹與聆聽亞洲最大的管風琴，也可以透過這本繪本，親近管風琴這項樂器。

衛武營從2018年開幕以來，每年都會邀請享譽國際的管風琴家來這裡演奏，並錄製管風琴專輯，目標就是希望能充分發揮這個亞洲唯一得天獨厚、獨一無二的珍貴大樂器。最後，希望透過這本繪本，讓讀者有機會在衛武營聆聽管風琴演奏時，能更具體感受到管風琴的靈魂，愛上管風琴。

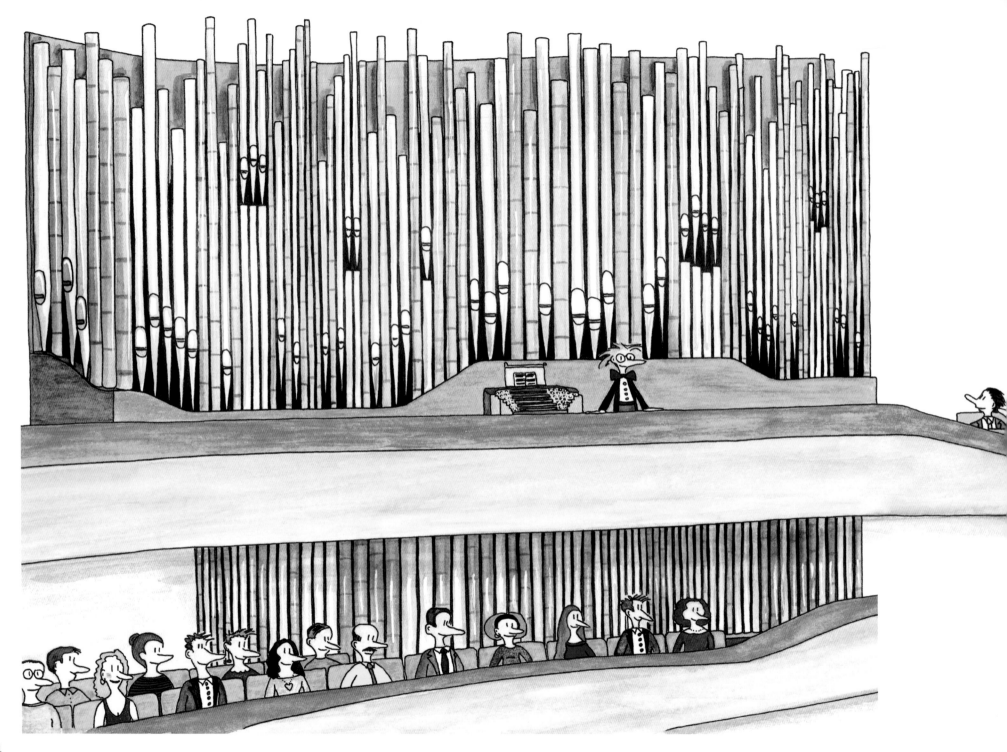

這座管風琴座落於高雄的衛武營國家藝術文化中心，這裡是全球最大單一屋頂綜合表演中心，它也是亞洲最大的管風琴。

衛武營音樂廳的管風琴看起來非常特別，讓人聯想起神奇森林裡的閃亮竹林。管風琴分為兩個部分。較大的部分稱為「主管風琴」，較小的部分稱為「回聲管風琴」。1位、2位甚至3位管風琴家，不論是否配合交響樂團，都可以個別或同時演奏。管風琴的絕佳聲響，讓聆聽倍感享受。接下來在本書中，您將會在這迷人的管風琴裡，發現許多有趣的細節。

This is the pipe organ of the National Kaohsiung Center for the Arts (Weiwuying). It is located in the world's largest single-roof theater-complex and it is the biggest one in Asia.

The organ of Weiwuying Concert Hall looks very special and reminds of a magical forest of shiny bamboo stems. It has two parts: the bigger one is called "Symphonic Organ" and the smaller one "Echo Organ". One, two or even three organists can play them separately and together, with or without an orchestra. It has a great sound, and it is a real joy to listen to it. Further in the book you will find many interesting details about this fascinating instrument.

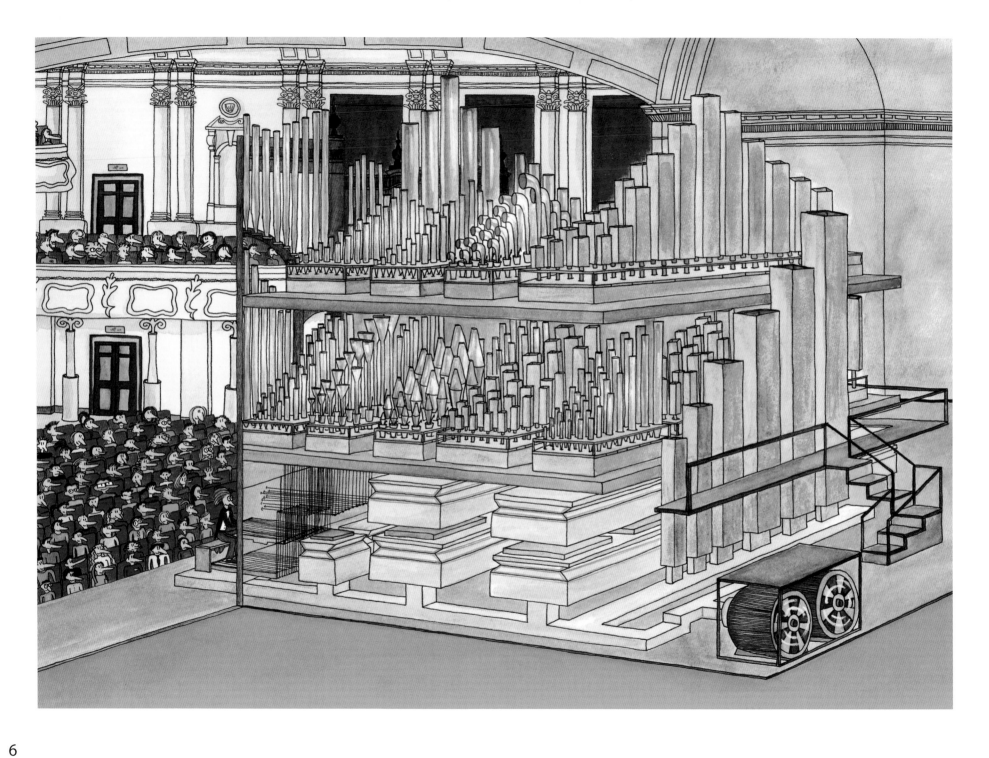

管風琴被稱作是「樂器之王」，在所有樂器之中它是最大的。它可以發出非常大的聲響，但音量不是它的全貌，更重要的是，它可以同時演奏出許多不同的豐富音色，甚至取代整個交響樂團。

每座管風琴的設計與建造都是獨一無二的，任何地方都不會有二台一模一樣的管風琴。

一台管風琴可以小到像一個櫃子，也可以大到像一間房子。只有管風琴才會如此壯觀並裝飾得富麗堂皇。有些管風琴上也鑲嵌著會動的金色星星與天使，有些管風琴的手鍵盤是由真的象牙所做成，甚至有些管風琴還會在音管上繪製藝術彩繪。每台管風琴都是獨一無二的，看起來獨特，聽起來的感覺也不同。

管風琴看得見的部分就只有最外圍的正面音管，但是在正面音管後面仍有非常多的音管。衛武營國家藝術文化中心的管風琴有四層樓高，在這座管風琴裡，有許多樓梯間與通道可以彼此互通。這台管風琴重達近55噸！裡面共有9,085支音管，三台大型鼓風機，甚至配有電腦。

The pipe organ is called the "King of Instruments". Of all instruments the organ is the largest. It can be played very loudly, but volume is not everything. More important, it is able to create such an abundance of tone colours that, so it is said, it can replace an entire orchestra.

Every organ is designed and built individually, and there are no two identical organs anywhere.

A pipe organ can be as small as a chest of drawers, but it can also be as big as a house. Only an organ can be so magnificently and so creatively decorated. One has movable golden stars and angels, another one has keys made of genuine ivory, the pipes of the third one are artistically painted. Each one is unique, looks different and sounds different.

What is visible of the organ is only the façade, called the "organ case". Yet there is much more behind. The organ of the National Kaohsiung Center for the Arts (Wei-wuying) has four floors, several stairs and many passageways that guide through the entire instrument. It weights nearly 55 tons! Inside are more than 9,085 pipes, three giant motors and even a computer.

音管是管風琴的聲音來源。管風琴製造廠的技師甚至會形容它們是「音管在說話」以及他們聽見「音管在演說」，也就是說管風琴的音管正在發出聲音。

管風琴的音管由不同的材料製造而成，通常是金屬與木材。二種都可以表現出極小聲或大聲、磅礴的音量或柔和的聲音。通常木質音管的音色聽起來較柔和、溫暖，而金屬音管的聲音通常較為尖銳、具穿透力。管風琴音管的聲音依照形狀與尺寸會有所不同。

這裡有至少24種不同形狀的音管。有些聲音是管風琴自己本身獨有的，其它的音管是模仿其它樂器的音色，例如直笛、低音管或小號。這也就是為什麼每台管風琴在音色與音量上是如此的不同，可以有無限多種聲音的組合。

管風琴的音高依據音管的長度會有所不同，音管越長，發出的聲音越低沉。

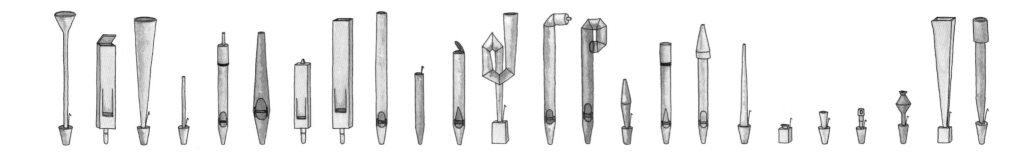

Pipes are the voices of the organ. Organ builder even say "pipes speak" and they hear "pipe speech", that means the pipe is making a sound.

Pipes are made from different materials, usually from metal and wood. Both can be loud or quiet, powerful or gentle, but generally wood pipes sound warm and soft, while metal ones often produce a harsher sound. The character of the sound that pipes produce also depends on the shape, weight and size of the pipes.

There are at least 24 different shapes of pipes. Some have voices only organs have. Other pipes can imitate other instruments like recorders, bassoons or trumpets. That's what makes the organ so incredibly versatile: there is an endless number of possible combinations!

The pitch of a pipe is decided by its length. The longer the pipe is, the lower the sound it makes.

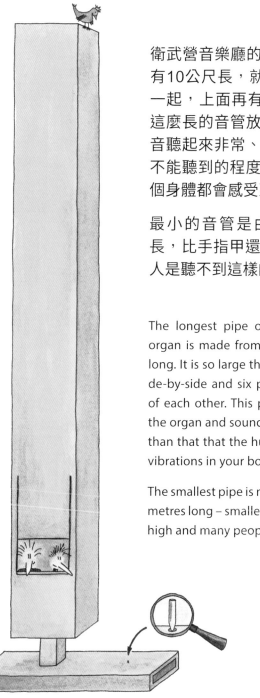

衛武營音樂廳的管風琴，最大的木製音管有10公尺長，就好像有2個人肩並肩站在一起，上面再有6個人疊加上去這麼高。這麼長的音管放置於琴的最後方，它的聲音聽起來非常、非常的低，幾乎低到人耳不能聽到的程度，但是當聲音出來時，整個身體都會感受到音頻的振動。

最小的音管是由金屬製成，只有6釐米長，比手指甲還小，聲音非常的高，許多人是聽不到這樣的音高。

The longest pipe of the Weiwuying Concert Hall organ is made from wood and is nearly 10 meters long. It is so large that two people can stand in it side-by-side and six people could stand in it on top of each other. This pipe stands at the very back of the organ and sounds very, very deep - even deeper than that that the human ear can hear. But you feel vibrations in your body when it sounds.

The smallest pipe is made of metal and is only 6 milli-metres long – smaller than a fingernail It sounds very high and many people cannot even hear it.

所有的音管都由一樣的材質製造，有著一樣的形狀與音色，這些音管排列在一起，我們稱做「音列」。每列音管中，不同高度的音管對應到每個琴鍵，也就是說，每列音管有61支音管，對應到手鍵盤的61個琴鍵，以手來彈奏，32支音管對應到腳鍵盤32個琴鍵，以腳來彈奏。

管風琴的大小取決於音列的數量。一台有60音列的管風琴可說是大型的，相較於只有20音列的管風琴則算是小型管風琴。衛武營國家藝術文化中心的二台管風琴總共有158組音列、827支木音管與8,258支金屬音管。世界上僅有少數的管風琴比衛武營的管風琴還大。

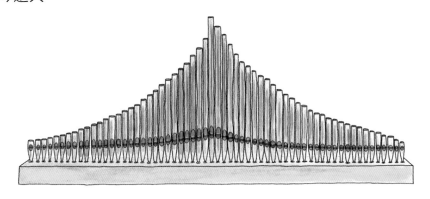

Pipes that are made of the same material, have the same shape and sound are called a "rank". Every pipe in the rank has another length and belongs to one of the keys at the keyboard. This means each rank has 61 pipes for 61 keys played by the hands and 32 pipes for 32 keys played by the feet.

The size of the organ is described by the number of ranks it has. A 60-rank instrument is a fairly large size while a 20-rank instrument is rather small. Both organs of the National Kaohsiung Center for the Arts (Weiwuying) combined have 158 ranks! There are 827 wooden and 8,258 metal pipes. Only few pipe organs in the world have more.

一台管風琴可以發出多種不同的聲音。每一種音色稱為一個音栓。大多數的音栓和音列一樣是各自對應一個音管。但是有時候一個音栓會用到多個音管，因為是它的音色是多支音管所組成。每個音栓都有自己的名字來形容它們的聲音，例如「雙簧管」或是「混合音栓」。

演奏家藉著拉與推來製造一個或多個音栓，拉出來可以發出音栓，推進去可以關掉音栓。

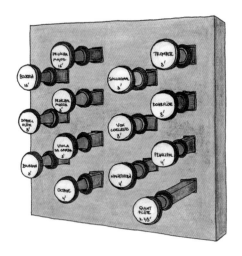

A pipe organ has many voices. Each kind of voice is called a stop. Mostly a stop has so many pipes as a rank does. But sometimes a stop has more, because some kinds of sounds use several pipes for one note. So that the organist can tell the difference between these stops, each stop has its own name that describes its sound, for example "Oboe" or "Mixture".

To play the organ the organist has to activate one or more stops by pulling out drawstops. When he pushes the drawstop in, the stop won't sound any more.

一台管風琴通常會擁有許多音管，因此一組鍵盤是不夠用的。擁有越多音栓的管風琴，會需要越多的鍵盤。傳統上這些管風琴鍵盤被稱為「手鍵盤」。衛武營音樂廳的管風琴有5組手鍵盤，每個手鍵盤各有61鍵，由36個白鍵與25個黑鍵組成。白鍵是使用象牙色的動物骨骼製作，黑鍵則是使用黑檀木製作，黑檀木是一種非常堅固的黑色木頭。

演奏管風琴不單是用手彈奏，同時也需要用到雙腳。由腳彈奏的部分稱為「管風琴腳鍵盤」，腳鍵盤上共有32個長鍵。

管風琴的音管是無法控制大、小聲的音量變化，事實上同一支音管的聲量總是一樣的。但是藉由操作腳鍵盤上的三個「表情踏板」，管風琴家可以藉由這踏板來調節一些音管的音量。被選擇的管風琴音管音列，位於有大開闔百葉木片的特別木箱裡。藉由百葉木片的開闔，可以讓管風琴音管的音量聽起來有大小聲的變化。

A pipe organ has usually so many pipes, that one keyboard is not enough. The more stops the organ possesses – the more keyboards are required. Traditionally they are called "Manuals". The pipe organ of the National Kaohsiung Center for the Arts (Wewuying) has five manuals with 61 keys each: 36 white keys and 25 black. The white ones are covered with animal bones which look like ivory, while the black ones are made from ebony, which is a very hard, black wood.

The organ isn't just played with the hands, but also with the feet. The keys for the feet are called "pedals" and make up the „pedalboard". The pedalboard has 32 big long keys.

You cannot make a pipe sound loud or quiet, actually it sounds always the same. But by means of the additional three "swell pedals", those above the pedalboard in the centre, the organist can adjust the volume of some pipes. Selected ranks of pipes are positioned in special wooden boxes with big shutters. Swell pedals open and close these shutters, allowing the pipes to be heard more or less.

管風琴家演奏位置的手鍵盤、腳鍵盤、音栓與琴椅，組合起來即是「演奏台」，這是管風琴的協調中心，也是最精密最複雜的大腦部分。

衛武營國家藝術文化中心的管風琴甚至有三個演奏台！其中二台分別與主管風琴、回聲管風琴連接著，第三個演奏台則是可以移動，可以放置在舞台的任何一個地方。三台演奏台彼此都聯結著，因此管風琴家可以有許多不同的方式來演奏二台管風琴。

The manuals, the pedalboard, the drawstops and the bench (for the organist to sit on) make up "console". The console is the control centre of the pipe organ and in a way, its head. It is the most complex and complicated unit of the instrument.

The organ of the National Kaohsiung Center for the Arts (Weiwuying) has even three consoles! Two are mounted directly on the cases of "Symphonic" and "Echo" organs, the third console is movable and can be placed on demand on the stage. All three are connected to each other, therefore there are different options from where the two parts of the organ can be played.

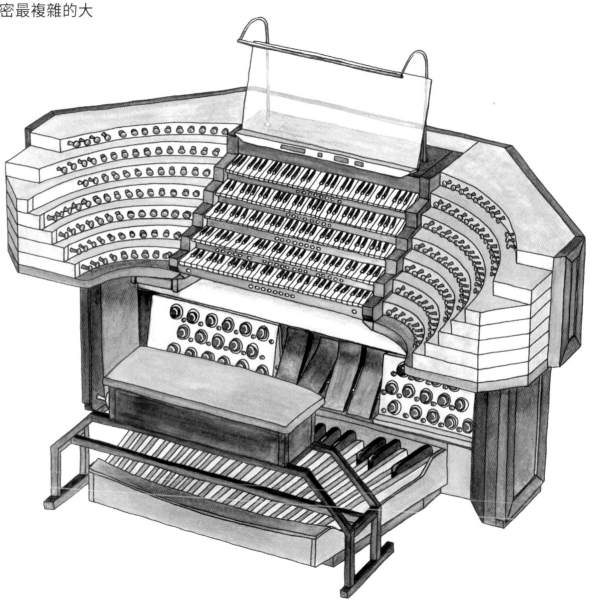

A pipe creates a sound when wind flows into it. This is like blowing into a flute, just that an organ has many pipes of different size to be blown in at the same time.

For older organs, before electricity was introduced, small wedge-shaped bellows were enough. It works as follows: when expanded, the valve inside the bellows opens and the air fills its cavity. When squeezed shut again, the air is forced out in a stream to pipes so that they sound.

Actually organ builders say "wind" instead of "air" when talking about organ mechanics. The difference is that the "wind" is pressed out of some container and has direction, and air is just motionless.

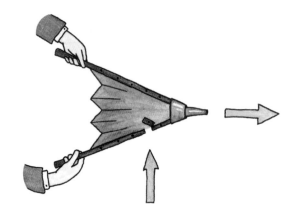

音管的發聲是當風從音管吹進去的時候就會發出聲音，運作方式就如同一般的長笛一樣。只不過管風琴是從很多不同大小的音管在同時間吹氣、發出聲音。

在電力發明之前，老式的管風琴使用小型的楔子型鼓風箱就足夠了。它的工作原理如下：當鼓風箱擴張的時候，鼓風箱裡面的止風閥會開啟，空氣便會充滿在空腔中，當鼓風箱再次被擠壓、開、關閉的時候，空氣會被擠壓到音管使音管發出聲音。

事實上，製造管風琴的技師提到管風琴的機械原理時會強調「風」而不是「空氣」。其中最大的差異是「風」會從儲風箱中被送出，是有一定的方向，然而「空氣」是靜止、無方向性的。

愈大的管風琴當然是需要愈大的風箱系統，通常需要許多個來運作。最初的風箱系統是由人力運用整個身體的重量與腳配合來施壓運作。而今日，管風琴已具備強而有力的馬達來驅動大風扇運轉，我們稱做「鼓風機」。

「鼓風機」可供給足夠的風量給音管，這就好像我們的呼吸一樣。但風的流動不會是非常平穩的，它會是像波浪一樣流動，這就是為什麼現代的管風琴會需要有「儲風箱」。儲風箱是放置於鼓風機及風箱之間來引導風的流動，將風輸送到所有的音管。它可調節、控制風量的流動，讓音管發出平穩、順暢的聲音。

越多音管就需要越多的儲風箱，衛武營國家藝術文化中心的二台管風琴內就有18個大型儲風箱。主管風琴內有14個儲風箱，回聲管風琴有4個。儲風箱就如同整台管風琴的肺一樣。

Larger pipe organs need larger bellows, of course, mostly several ones. Big bellows were originally operated with feet and entire body weight. Today pipe organs have powerful motors that actuate big fans, called "blower".

A blower generates enough wind for many pipes. But the wind from the motor doesn't flow smoothly, it flows in waves, almost like breathing. That is why also in modern pipe organs bellows are still needed. They are placed between the blower and trunks that lead wind further to the pipes. Bellows regulate the wind flow and allow the pipes to sound smoothly.

The more pipes there are, the more bellows are needed. The two organs of the National Kaohsiung Center for the Arts (Weiwuying) possess 18 giant bellows. The Symphonic Organ has got 14 bellows and the Classic Organ 4. Bellows are the lungs of the organ.

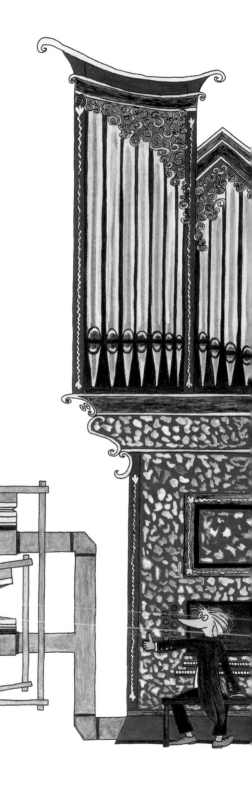

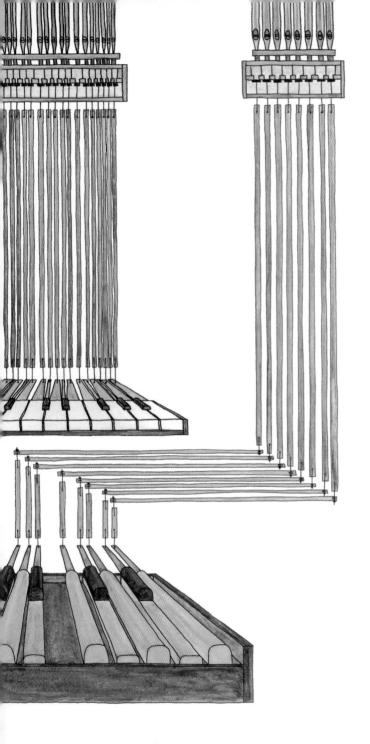

為了避免屬於一個音階內的所有音管同時發出聲音。每個音管的底部都設有一個小型控制閥，透過這控制閥的開啟或關閉讓風進入音管。它們的運作是直接由手，或腳鍵盤的琴鍵來控制。按一個琴鍵時可以把一個閥門打開。每個閥門下都有安裝金屬彈簧，所以當手指放開時，琴鍵也會往上彈回原位。控制閥與琴鍵間連結著一條長木桿，稱為「牽拉片」。

牽拉片的機械裝置透過聯合接點可以長達數米長，讓位於遠處的演奏台可以連結到所有音管。

一個只有1釐米厚與8釐米寬的牽拉片看起來非常脆弱，實際上也可輕易的折斷。但非常驚訝的是，這麼細又輕的牽拉片卻是堅固的，它可以承受超過3噸重的的拖曳力。

衛武營國家藝術文化中心的兩台管風琴重量驚人。主管風琴的重量幾乎是回聲管風琴的五倍。這兩台管風琴加起來大概有25頭大象那麼重。

To avoid all pipes belonging to one stop sound at the same time, each pipe has a small valve underneath. These open or close to admit wind to the pipe. Their movement is controlled directly by the keys of the manual or pedalboard. Pressing a key down pulls the valve open. Each valve has a spring underneath so that the key returns to the „up" position when released. The valve and the key are connected by a long wooden rod, called "tracker".

The tracker mechanism can be several meters long with many junctions and joints, because most of the pipes are placed far away from the console.

A tracker is only one millimeter thick and eight millimeters wide. It appears very fragile and is in fact very easy to break. Nevertheless it is astonishingly strong. Such a thin and light rod can resist more than three tons of drag!

The two organs of the National Kaohsiung Center for the Arts (Weiwuying) are very heavy. The Symphonic Organ is almost five times as heavy as the Echo Organ. Both organs combined weigh as much as 25 elephants.

管風琴是世界上最大與最複雜的樂器。管風琴演奏家如何一個人來操控呢？有趣的是，它的運作機制比想像中簡單。

當管風琴的鼓風機馬達關閉時，你可以盡情的彈奏喜歡的琴鍵，都不會發出任何聲音，因為音管需要有風才會發出聲音。

當鼓風機的馬達開啟後，風箱開始運作，此時所有的風箱裡立刻充滿了風。

風箱會聯結至一個平面木製的箱子，稱為「風肺」，上方有許多音管。風肺內部裝有演奏台上鍵盤控制的小閥門，風肺最重要的功能是確保所有的音管不會同時發聲。

管風琴現在準備開始彈奏了，但即使您彈鍵盤上的任何一鍵，管風琴也不會發出聲音，因為在音管下方的風肺裡面有二道風力關卡。

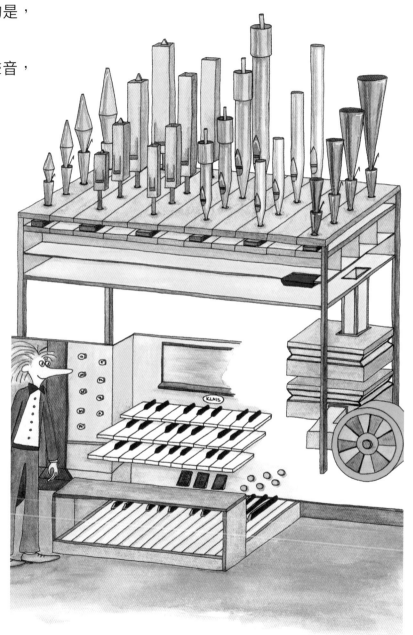

The pipe organ is the biggest and most complex musical instrument in the world. How can an organist handle all this alone? It is interesting to see that its mechanism is actually rather simple.

When the motor of the organ is off, you can do anything you want and press any key you like, there will be no sound. Pipes wait for the wind.

When the motor is turned on, the blower starts working and all the trunks are immediately filled up with wind.

A trunk leads to a "windchest". This is such a plain wooden box with many pipes atop. Inside the windchest are all the small valves operated by the keys at the console. So the windchest is important for the pipes not to sound all together at the same time.

The organ is now ready to be played, but even if you press any key, there will be no sound yet. In the windchest beneath the pipes there is a double barrier for the wind.

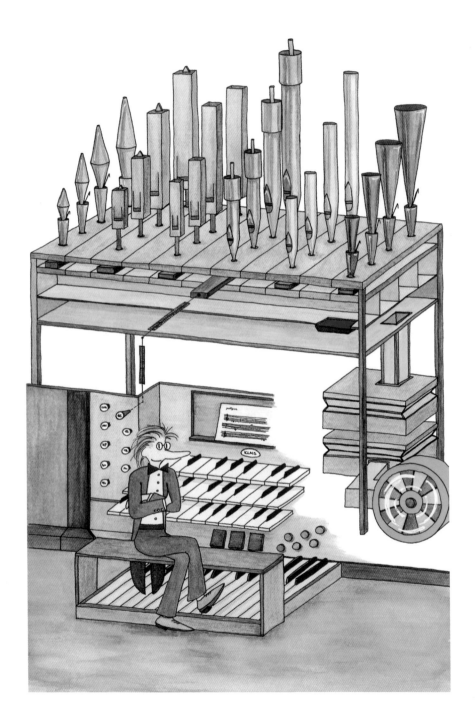

第一道關卡稱為「滑板」，滑板看起來像一個長條有孔的板條。這些孔對應到儲風箱頂部上一排列的孔。在一列的儲風肺的頂上架設一列的音管，這就是一個「音栓」。

當管風琴演奏家拉開音栓時等於移動了一個滑板。當滑板上的孔調整到與音管的開口排列對齊時，風箱裡面的風便可流過那些孔。包含許多音管的一支音栓現在準備好要發聲了！但是那裡仍然沒有風，因為第二道關卡關起來了。

The first barrier is called a "slider" and it looks like a thin strip of wood with holes in it. These holes correspond to a row of holes in the top of the windchest. And atop one row of the windchest holes stands exactly one row of pipes – this is one stop.

When an organist pulls a drawstop, he moves a slider. When the holes on the slider align with the openings of the pipes, the wind from the trunk can flow through them, the pipes of one stop are now ready to sound. But there is still no wind, because the second barrier is closed.

當管風琴演奏家彈奏手鍵盤或腳鍵盤的琴鍵時，第二個關卡會開啟。這個琴鍵是與牽拉片相連，牽拉片的末端有控制閥門。比方說當演奏家要彈奏琴鍵A時，牽拉片會往下移動，同時牽拉片也開啟了控制閥。因此，控制閥會讓風在A的音管裡面流動。

滑板與溝槽A是對應成直角。它們一起引導風的流向，確認音管發聲。

為了使管風琴發聲，管風琴家必須同時打開兩道關卡才能讓它發出聲音。這意指管風琴家必須至少拉出一支音栓，同時至少彈一個音鍵，樂器才會發出聲響。

The second barrier opens when the organist presses a key on the manual or pedalboard. The key is connected to the tracker and the tracker has a valve at its end. When a player presses for example note "A", he makes the tracker move down, and the tracker opens up the valve. The valve admits wind to the groove with all the pipes "A" above.

The slider and the groove "A" are at right angles to each other. Together they guide the wind flow and define which pipe will speak.

For the organ to sound, the organist has to open both barriers at the same time. This means he has to pull out at least one drawstop and at the same time press at least one key.

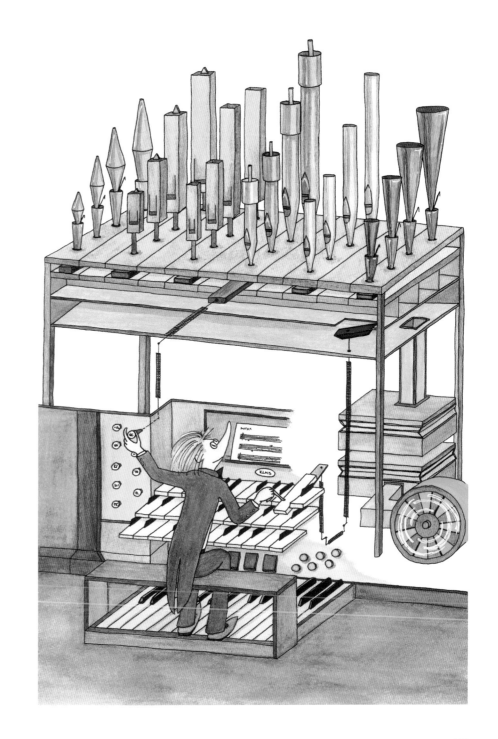

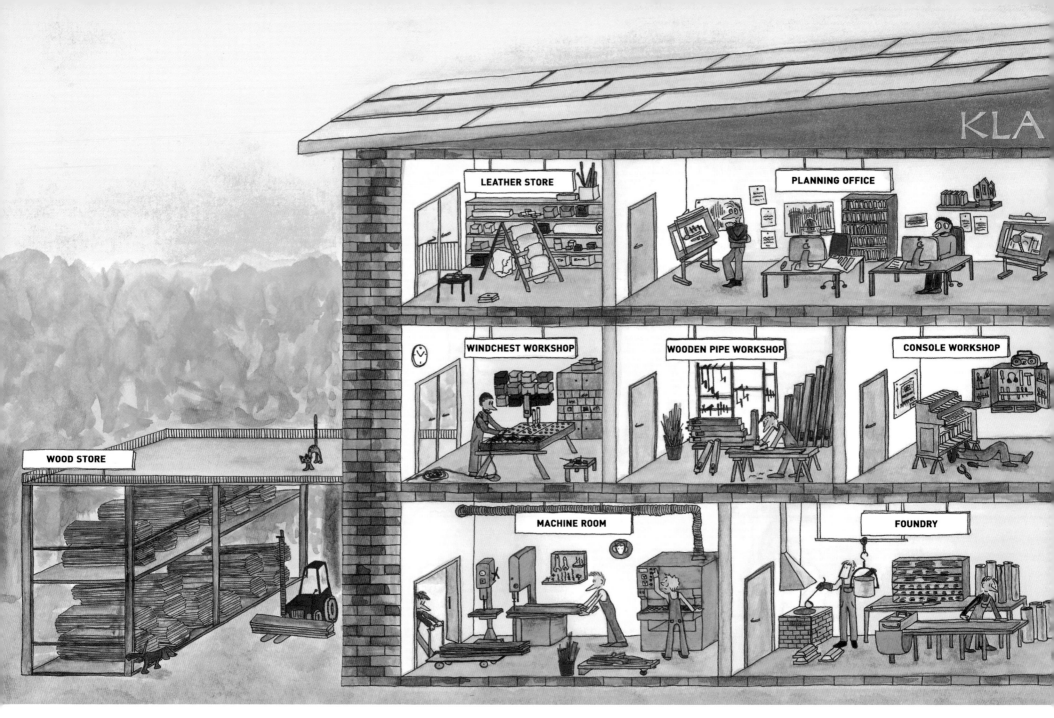

管風琴從不會在現場直接丈量安裝，因為整個建構過程需要許多的時間、空間、特別的機器，以及許多不同領域的專家一同建造。所有這些部分，都只能在管風琴工作室裡看到。

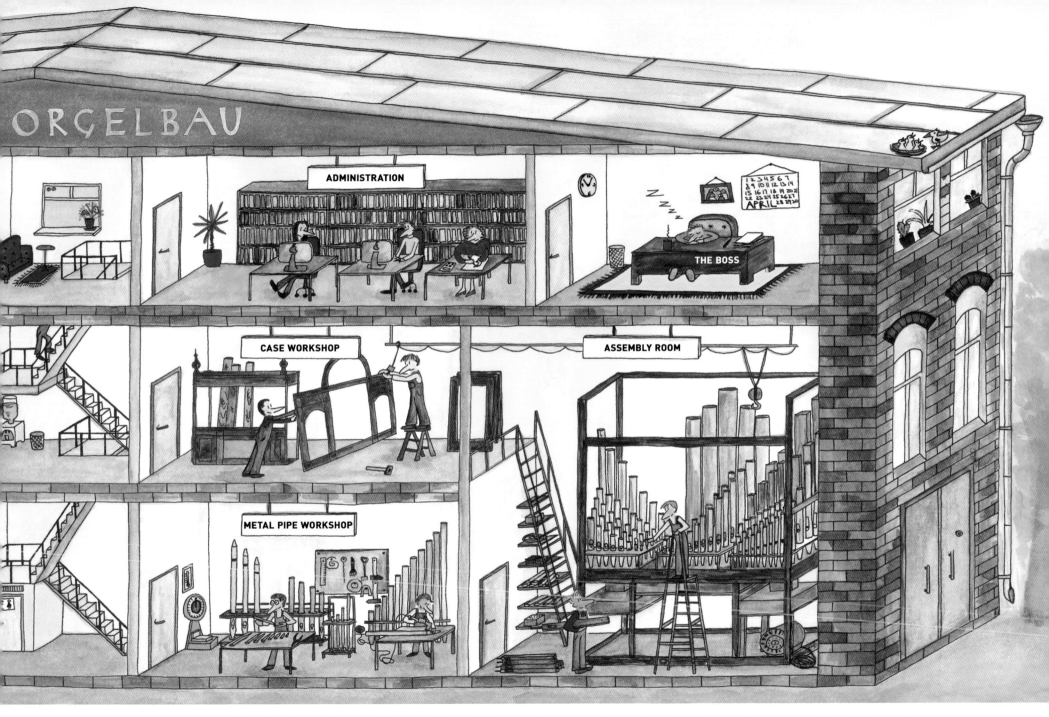

The pipe organ is never built in the place where it will eventually stand, because the process demands much time, much space, special machines and many different specialists. All these you can find only in an organ builder's workshop.

管風琴工作室有許多部門。

There are different departments in the organ builder's workshop.

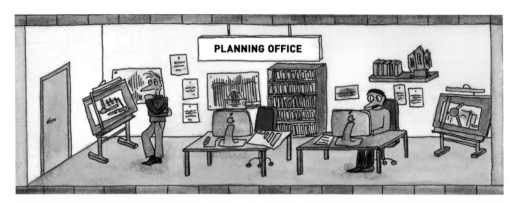

在規劃部門裡，建築師與工程師謹慎地討論新管風琴的設計與整體聲響效果，還有如何重建翻新一台老舊的管風琴。他們也一起計算，會使用到多少不同的材料來建構管風琴。

The organ architects and organ engineers sit in the planning office. It is their job to design new organs or to think about how older organs should be restored. They also calculate carefully which and how much material they will need for the job.

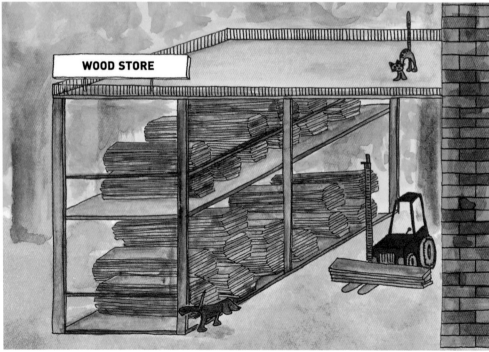

在木材儲藏室裡，樹木被裁成許多木板。這些被用來建造管風琴的木材，有雲杉木、橡木、山毛櫸、洋梨樹與白樺樹。這些木材需風乾至少10年以上，才能成為建造管風琴的好木材。有些木材放置超過200年，有些甚至超過400年以上。

Logs are stored in the wood store. The wood usually used for organ building is spruce, oak, beech, birch and pear tree. It takes up to ten years before the logs are dry enough to be used in an organ. Many logs are over 200 years old and some are even 400 years old.

在機械室裡，木材經過裁切、整平、刨光與塑型，並準備於後續階段的處理。

In the machine room, the wood is worked – cut, planed, shaped and prepared for further treating.

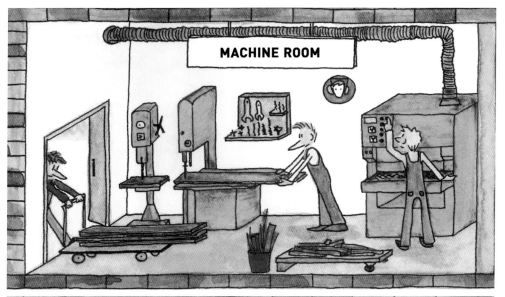

在鑄造廠裡，錫條被放置在一個特殊的熔爐內加熱直到它們融化成液體。熔解的金屬會被燒鑄成一片一片又大又薄的金屬片。

In the foundry, tin bars are heated up in a special oven until they become liquid. The liquid metal is then poured into large, thin sheets.

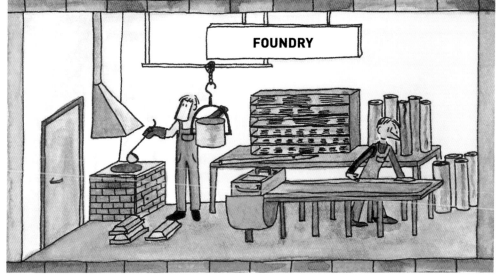

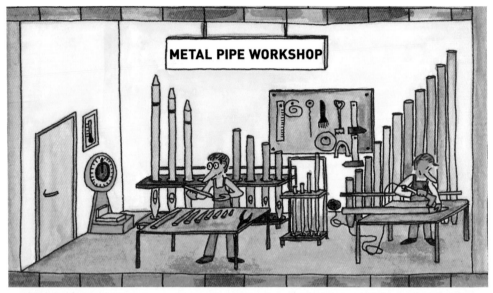

然後，在金屬音管工作室中，一片一片的金屬音管片會被裁切成不同大小尺寸，金屬音管都是在這個工作室內完成的。

Later on, pipes of all shapes and sizes will be cut out of these sheets. This is done in the metal pipe workshop.

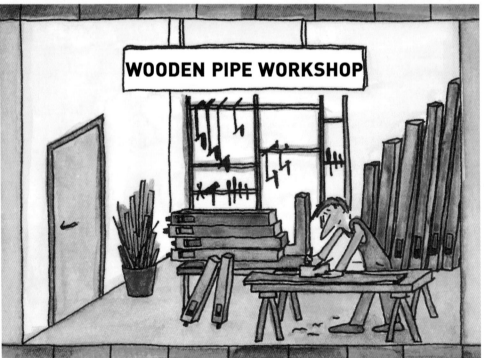

木質音管則是在木質音管工作室中製造。根據不同尺寸、大小、外型與重量，所有的音管有著不一樣的聲音。一位音管製造技師需要許多年的經驗，才得以勝任這項工作。

Wooden pipes are produced in the wooden pipe workshop. Depending on size, shape and weight, all pipes sound differently. A pipe maker needs many years of experience.

風肺在風肺工作室製作完成。

In the windchest workshop the windchests are made.

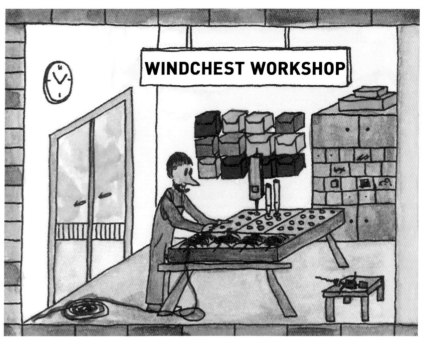

在毛皮儲藏室裡，存放著小羊、綿羊、袋鼠、山羊的毛皮。毛皮必須柔軟又具韌性，以符合儲風箱需要。這樣儲風箱運送風至音管時，才不會因膨脹而破裂。

Leather from lambs, sheep, kangaroos or goats is kept in the leather store. It not only has to be very soft but also hard-wearing as it is used later for the bellows. It must be strong enough to withstand the pressure from the air inside the bellows.

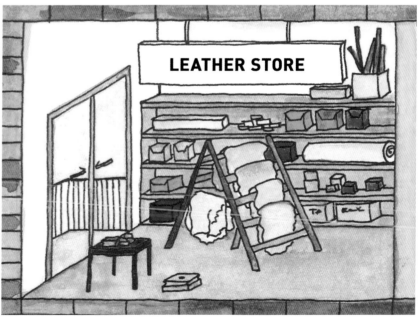

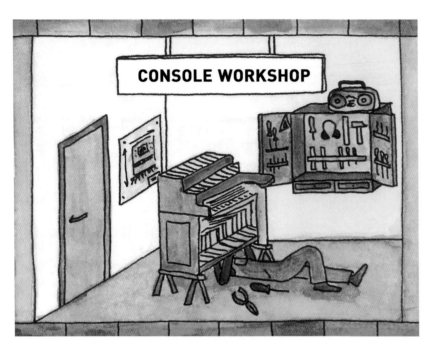

演奏台於演奏台工作室製作。

For the consoles there is also a console workshop.

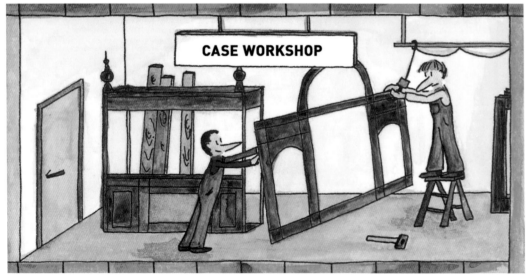

管風琴外面與裡面的框架叫做「管風琴外殼」。製作過程非常複雜，也需要使用到大量的時間和精力，這都是在框架工作室內完成。

The inner and outer framework of the organ is called the "case". Making cases requires a lot of time and effort as they are often very intricate. They are made in the case workshop.

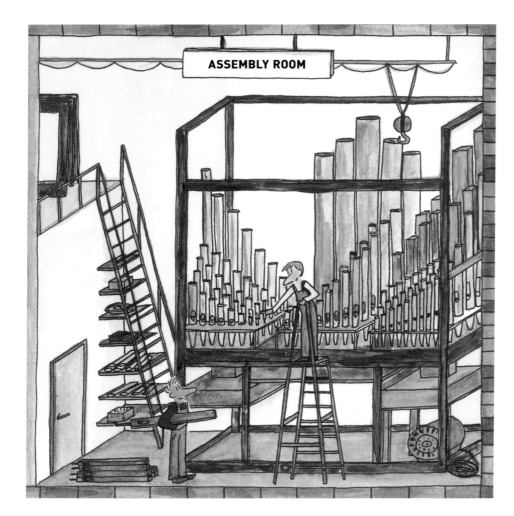

全新的管風琴會先在裝配室被組裝完成與完整測試，確保每一機件與聲音都能正常運作。

The new organ is first of all fully built completely in the assembly room and then tested to see if everything works properly and sounds okay.

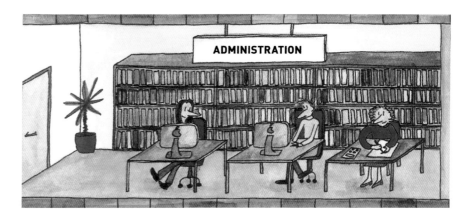

行政室負責所有工作的組織與程序。不論是工作室需要訂購螺釘，或是所有員工是否都滿意自己的工資——以上所有事情，都是由行政部門每天要處理的大小事。

The administration is responsible for the organisation and the construction process as a whole. Whether enough screws were ordered for the workshop or whether all employees are happy with their wage – the administration needs to take care of all of those aspects on a daily basis.

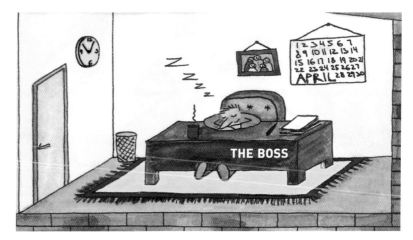

最後當然是由老闆督導每一件事！
And the boss supervises everything, of course!

當所有工作室的工作都完成並且檢查完畢，管風琴會被一一拆解並準備運送到最後的目的地。所有的音管都會被貼上標籤並用軟紙包裝；所有的零件也會小心的標記並包裝至木箱中，以免有任何零件會損壞或遺失。這也讓管風琴的組裝變得容易，且可以將管風琴正確地組裝一起。

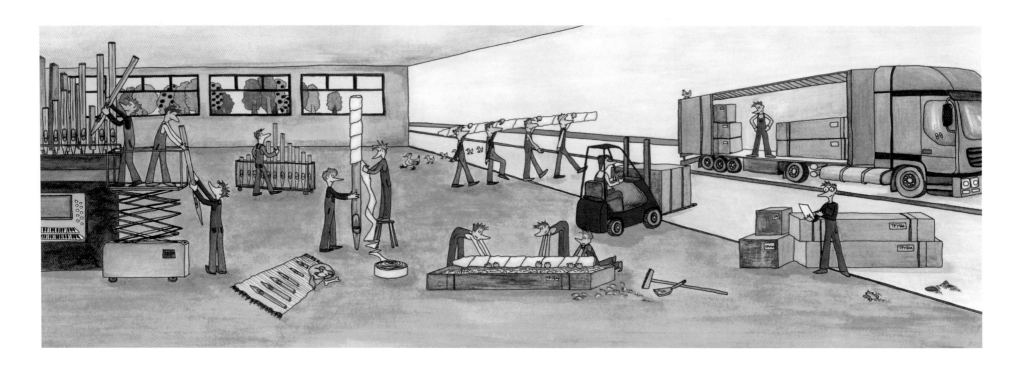

After the organ is finished in the workshop it is taken apart again and prepared for its transport to its final destination. All pipes are labelled and wrapped up individually in soft paper. All parts of the organ are numbered and carefully packed into boxes so that nothing breaks or goes missing. That makes it easy to put the organ together correctly.

德國波昂與衛武營國家藝術文化中心相隔9,500公里遠（大約6,000英哩），整座管風琴需要分裝在11個大貨櫃中，透過大型輪船在海上運送與貨車在陸地上的接駁，光是運送時間就要超過六個星期。

The city of Bonn in Germany, where the organ for the National Kaohsiung Center for the Arts (Weiwuying) was built, is over 9,500 km (almost 6,000 Miles) away from Kaohsiung. For this journey the whole organ had to be packed into 11 huge containers and transported on big ships and trucks over water and land. Only the transport has taken more than six weeks.

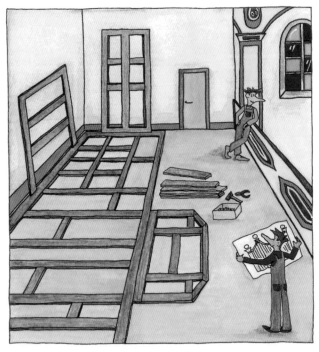

當所有的東西都抵達現場，所有零件將被拆裝、分類並開始準備架設、組裝。

建造一台管風琴就如同蓋一棟房子一樣，首先是地基與內框需先組裝完成。有時是需要非常複雜的結構框架才能讓工作人員在組裝管風琴時可以接觸到樂器各個角落。

然後，將儲風櫃與風肺放置其中，並讓導風管與牽拉片彼此相聯結。最後是安裝音管，這個部分需要有極大的耐心與注意力，因為每一支音管都需要放到確切的位置。

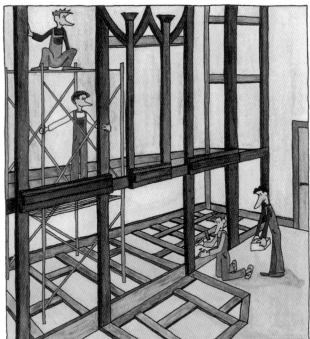

When everything finally arrives at the destination, it is unpacked, sorted and prepared for assembly.

An organ is built like a house - starting with the foundation up and from the outside inwards. First comes the base and the framework. Sometimes you need highly complicated structures to gain access to all corners of the instrument.

Then bellows and windchests are put inside. They have to be connected with trunks and trackers. Finally the pipes are installed. Here much patience and attention are needed, because every single pipe has to find its exact place.

當然，最重要且最複雜的工作就是整音，9,085支的音管都要依據音樂廳的音響環境來調整。

每一支音管都有自己獨特的聲音，不論是彎曲或是縮短的，音口的口徑也有大有小。每個細微的調整都會完全改變音管的音色。這就是為什麼，一位管風琴技師需要有非常好的聽力與技術。

這個階段需要持續三個月的時間，直到所有音管完美地發出聲音。

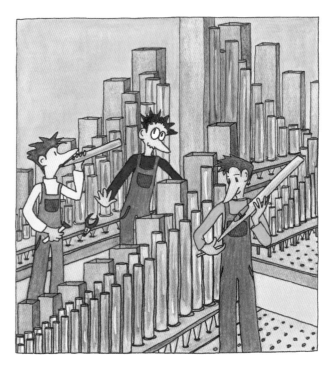

Still, the most important and most complicated work is voicing, which means that the sound of all 9,085 pipes had to be adjusted to the acoustics of the concert hall.

Every pipe was proved of its sound and then either curved or shortened, its mouth was enlarged or cut down. Every tiny modification can change the sound of the pipe completely. This is why an organ builder has to have a lot of skill and an excellent ear.

It took three months until all the pipes were perfectly voiced!

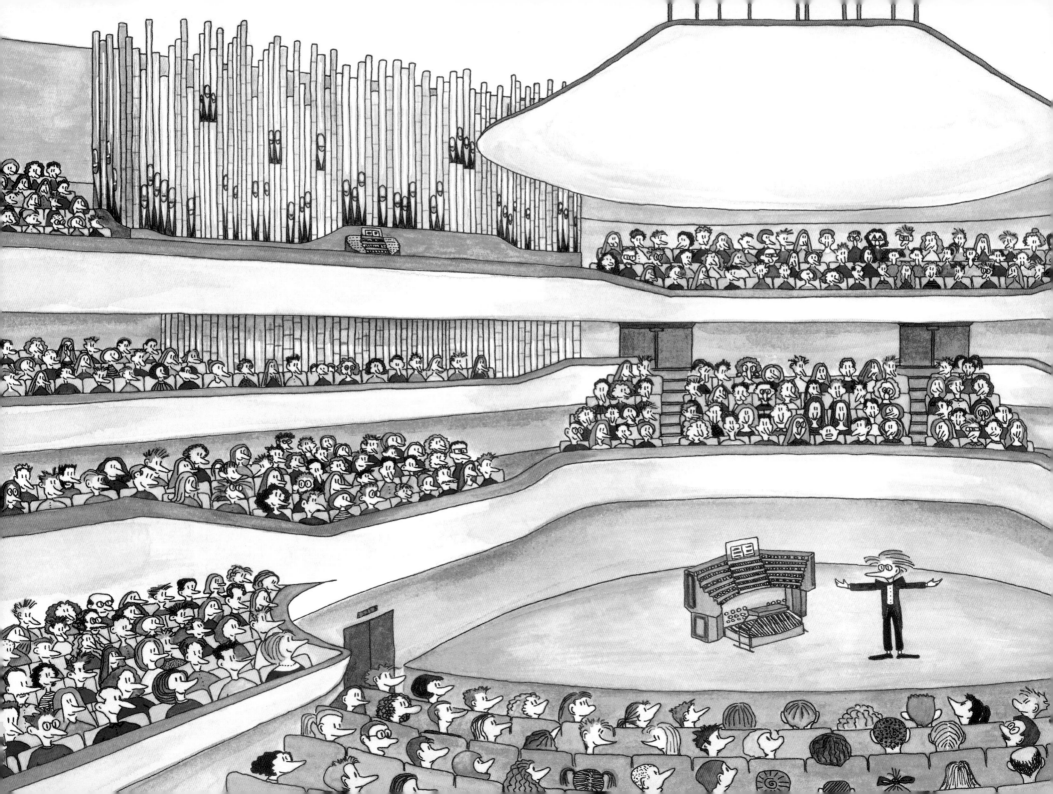

從最初的構思、提案草圖，到管風琴在衛武營國家藝術文化中心安裝完成，這當中有30位工作人員密集參與超過三年多的時間。

這座管風琴由世界著名的德國管風琴工藝製造廠「克萊斯管風琴」建造，從1882年起至今，他們所建造的管風琴已遍布全世界。

現在管風琴需要定期保養與調音，因為音管的聲音會隨著音樂廳裡的溫度與濕度而變化，所以管風琴技師將會好好照顧與保持管風琴的最佳狀態。歡迎隨時來衛武營國家藝術文化中心音樂廳欣賞管風琴演奏，享受樂器之王的神奇聲音。

From the first ideas and proposal drawings until the organ of the National Kaohsiung Center for the Arts (Weiwuying) in Kaohsiung was completed, 30 people have intensively worked for more than three years.

This organ was built by the famous German organ builder's workshop "Johannes Klais Orgelbau", where organs have been built and installed all over the world since 1882.

Now the organ has to be looked after really well and has to be tuned regularly. Although it looks so big and robust, it is, in fact, very sensitive. The sound of its pipes react to changes in temperature and humidity in the hall, and also just with the time. Organ builders will furthermore take good care of it and keep it in perfect condition. You can any time come to an organ concert and enjoy the magical sound of the King of the instruments in the Concert Hall of the National Kaohsiung Center for the Arts (Weiwuying) in Kaohsiung, Taiwan!

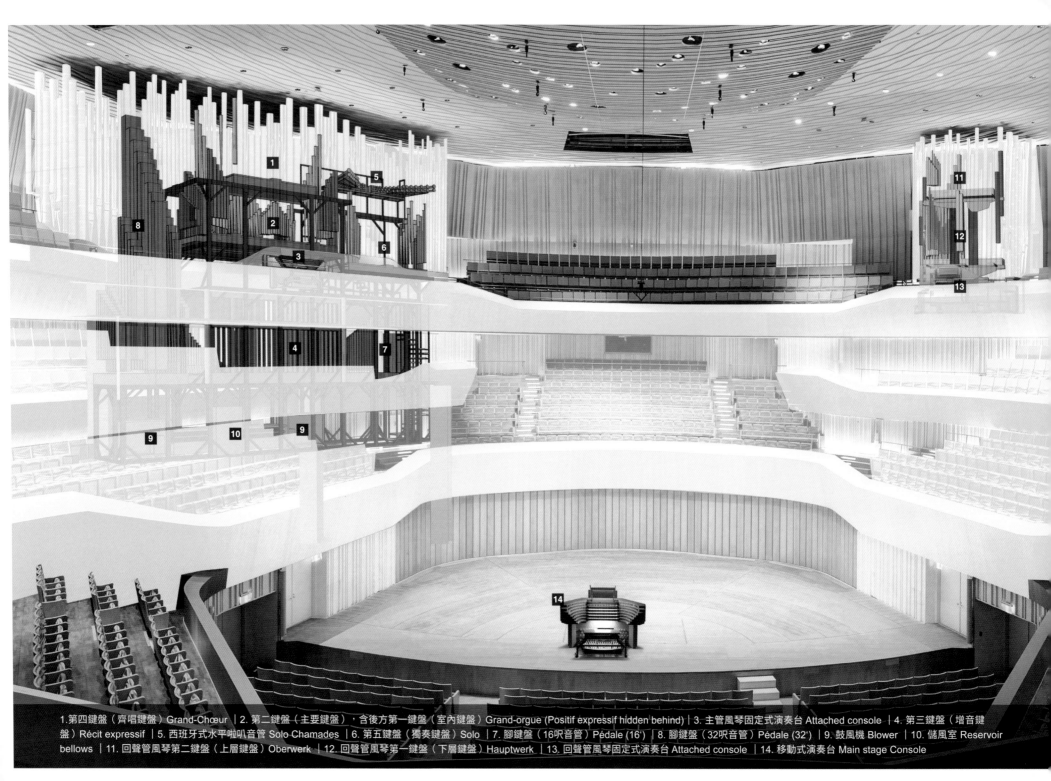

1.第四鍵盤（齊唱鍵盤）Grand-Chœur ｜2. 第二鍵盤（主要鍵盤），含後方第一鍵盤（室內鍵盤）Grand-orgue (Positif expressif hidden behind) ｜3. 主管風琴固定式演奏台 Attached console ｜4. 第三鍵盤（增音鍵盤）Récit expressif ｜5. 西班牙式水平啦叭音管 Solo Chamades ｜6. 第五鍵盤（獨奏鍵盤）Solo ｜7. 腳鍵盤（16呎音管）Pédale (16') ｜8. 腳鍵盤（32呎音管）Pédale (32') ｜9. 鼓風機 Blower ｜10. 儲風室 Reservoir bellows ｜11. 回聲管風琴第二鍵盤（上層鍵盤）Oberwerk ｜12. 回聲管風琴第一鍵盤（下層鍵盤）Hauptwerk ｜13. 回聲管風琴固定式演奏台 Attached console ｜14. 移動式演奏台 Main stage Console

管風琴音栓規格表 PIPE ORGAN SPECIFICATION LIST

主管風琴 Symphonic Organ *Total: 102 stops, 7,169 pipes*

I. Positif expressif (C-c4)

No.	Wood	Metal	Stop	Length(Ft.)
1	61	–	Quintaton	16'
2	–	61	Montre	8'
3	–	61	Salicional	8'
4	61	–	Bourdon	8'
5	–	49	Unda maris	8'
6	–	61	Flûte ouverte	4'
7	–	61	Violon	4'
8	–	366	Choeur de Violes VI 2	2/3'
9	–	61	Basson	16'
10	–	71	Horn	8'
11	–	6	Choeur de Rossignols	

11 stops, 919 pipes

II. Grand-orgue (C-c4)

No.	Wood	Metal	Stop	Length(Ft.)
1	–	61	Montre	16'
2	61	–	Bourdon	16'
3	–	61	Montre	8'
4	–	61	Salicional	8'
5	12	49	Flûte harmonique	8'
6	61	–	Bourdon	8'
7	–	61	Grosse Quinte	5 1/3'
8	–	61	Prestant	4'
9	–	61	Flûte ouverte	4'
10	–	61	Grosse Tierce	3 1/5'
11	–	61	Quinte	2 2/3'
12	–	61	Septième	2 2/7'
13	–	61	Doublette	2'
14	–	185	Cornet V	8'
15	–	366	Fourniture VI	2'
16	–	366	Cymbale VI	1 1/3'
17	–	61	Bombarde	16'
18	–	71	Trompette	8'
19	–	–	Chamade	16'
20	–	–	Chamade	8'
21	–	–	Chamade	4'
			Trémolo	

21 stops, 1,842 pipes

III. Récit expressif (C-c4)

No.	Wood	Metal	Stop	Length(Ft.)
1	61	–	Bourdon	16'
2	–	61	Diapason	8'
3	24	37	Flûte harmonique	8'
4	–	61	Viole de Gambe	8'
5	–	49	Voix céleste	8'
6	–	61	Octave	4'
7	–	61	Flûte octaviante	4'
8	–	61	Nazard harmonique	2 2/3'
9	–	61	Octavin	2'
10	–	61	Tierce harmonique	1 3/5'
11	–	244	Carillon IV	2 2/3'
12	–	366	Plein jeu VI	2'
13	–	–	Cornet harm. V	8'
14	–	61	Bombarde	16'
15	–	71	Trompette harm.	8'
16	–	71	Hautbois	8'
17	–	66	Voix humaine	8'
18	–	95	Clairon	4'
			Trémolo	

18 stops, 1,572 pipes

IV. Grand-choeur (C-c4)

No.	Wood	Metal	Stop	Length(Ft.)
1	–	61	Principal	8'
2	61	–	Bourdon	8'
3	–	61	Octave	4'
4	–	61	Nazard	2 2/3'
5	–	61	Quarte	2'
6	–	61	Tierce	1 3/5'
7	–	61	Larigot	1 1/3'
8	–	61	Septième	1 1/7'
9	–	61	Sifflet	1'
10	–	366	Grosse Fourn. VI	2 2/3'
11	–	366	Cymbale VI	1'
12	–	71	Grosse Trompette	8'
13	–	71	Cromorne	8'
14	–	112	Gros Clairon	4'
			Trémolo	

14 stops, 1,535 pipes

V. Solo (C-c4)

No.	Wood	Metal	Stop	Length(Ft.)
1	61	–	Flûte majeure	8'
2	–	61	Gambe	8'
3	–	49	Voix céleste	8'
4	–	61	Flûte de concert	4'
5	–	61	Grande Bombarde	16'
6	–	71	Trompette	8'
7	–	95	Clairon	4'
8	–	71	Cor anglais	8'
9	–	12	Chamade	16'
10	–	71	Chamade	8'
11	–	48	Chamade	4'

11 stops, 661 pipes

Pédale (C-g1)

No.	Wood	Metal	Stop	Length(Ft.)
1	-	-	Voix de baleine	64'
2	12	-	Flûte	32'
3	12	-	Soubasse	32'
4	-	-	Basse acoustique	32'
5	32	-	Flûte	16'
6	-	-	Principal Basse	16'
7	32	-	Soubasse	16'
8	-	-	Bourdon	16'
9	32	-	Grosse Quinte	10 2/3'
10	32	-	Flûte	8'
11	-	32	Octave	8'
12	12	-	Bourdon	8'
13	-	32	Grosse Tierce	6 2/5'
14	12	-	Quinte	5 1/3'
15	-	32	Septième	4 4/7'
16	-	32	Octave	4'
17	-	32	Flûte	4'
18	12	-	Petite Quinte	2 2/3'
19	-	12	Petite Flûte	2'
20	-	12	Piccolino	1'
21	-	192	Mixture VI	2 2/3'
22	12	-	Contre Bombarde	32'
23	32	-	Bombarde I	16'
24	-	-	Bombarde II	16'
25	32	-	Trompette I	8'
26	-	-	Trompette II	8'
27	-	-	Clairon	4'

27 stops, 640 pipes

Koppeln/Couplers

No.	Stop	
1	Tirasse Positif	I-P
2	Tirasse Grand-orgue	II-P
3	Tirasse Récit	III-P
4	Tirasse Grand-choeur	IV-P
5	Tirasse Solo	V-P
6	Tirasse Chamades	Ch-P
7	Grand-orgue au Positif	II-I

No.	Stop	
8	Récit au Positif	III-I
9	Grand-choeur au Positif	IV-I
10	Solo au Positif	V-I
11	Chamades au Positif	Ch-I
12	Positif au Grand-orgue	I-II
13	Récit au Grand-orgue	III-II
14	Grand-choeur au Grand-orgue	IV-II
15	Solo au Grand-orgue	V-II
16	Grand-choeur au Récit	IV-III
17	Solo au Récit	V-III
18	Chamades au Récit	Ch-III
19	Solo au Grand-choeur	V-IV
20	Chamades au Grand-choeur	Ch-IV
21	Octaves graves Positif	Sub/I
22	Octaves aiguës Positif	Super/I
23	Octaves aiguës Grand-orgue	Super/II
24	Octaves graves Récit	Sub/III
25	Octaves aiguës Récit	Super/III
26	Octaves graves Grand-choeur	Sub/IV
27	Octaves aiguës Grand-choeur	Super/IV
28	Octaves graves Solo	Sub/V
29	Octaves aiguës Solo	Super/V

回聲管風琴 Echo Organ *Total: 25 stops, 1,916 pipes*

I. Hauptwerk (C-c4)

No.	Wood	Metal	Stop	Length(Ft.)
1	12	49	Quintadena	16'
2	-	61	Principal	8'
3	12	49	Gedackt	8'
4	-	61	Gamba	8'
5	-	61	Octave	4'
6	-	61	Quinte	2 2/3'
7	-	61	Superoctave	2'
8	-	305	Mixtur V	1 1/3'
9	-	66	Trompete	8'

9 stops, 798 pipes

II. Oberwerk (C-c4)

No.	Wood	Metal	Stop	Length(Ft.)
1	12	49	Gedackt	8'
2	-	61	Quintadena	8'
3	-	61	Principal	4'
4	-	61	Rohrflöte	4'
5	-	61	Waldflöte	2'
6	-	61	Quinte	1 1/3'
7	-	122	Sesqualtera II	2 2/3'
8	-	244	Scharff IV	1'
9	-	66	Dulcian	8'
			Trémolo	

9 stops, 798 pipes

Pedal (C-g1)

No.	Wood	Metal	Stop	Length(Ft.)
1	32	-	Subbass	16'
2	-	32	Principal	8'
3	32	-	Gedackt	8'
4	-	32	Octave	4'
5	-	128	Hintersatz IV	2 2/3'
6	32	-	Fagott	16'
7	-	32	Trompete	8'

7 stops, 320 pipes

Koppeln/Couplers

No.	Stop	
1	II-I	Echo Organ
2	I-P	Echo Organ
3	II-P	Echo Organ
4	Hauptwerk – I	
5	Hauptwerk – II	
6	Hauptwerk – III	
7	Hauptwerk – IV	
8	Hauptwerk – V	
9	Hauptwerk – P	
10	Oberwerk – I	
11	Oberwerk – II	
12	Oberwerk – III	
13	Oberwerk – IV	
14	Oberwerk – V	
15	Oberwerk – P	

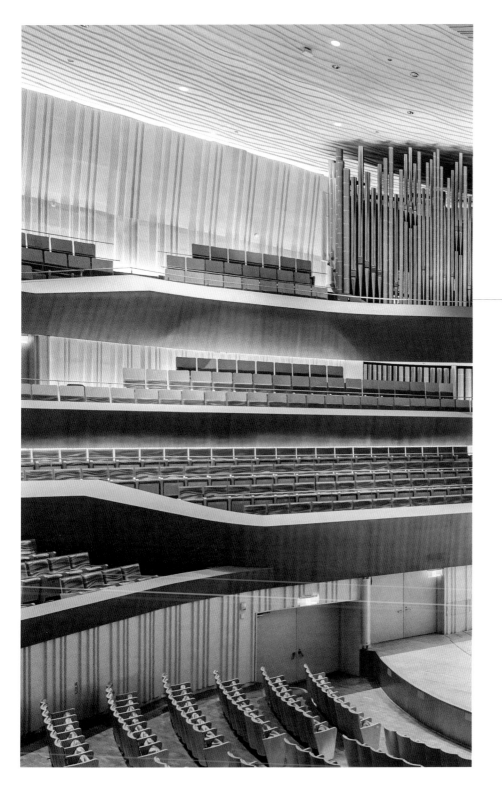

♫ 作者簡介

西妮雅·博尼希 Ksenia Bönig

西妮雅·博尼希在德國科隆傳播設計學院學習平面設計和插畫。在還是學生的時候，她就開始為兒童創作繪本，這些書籍已在世界各地以7種語言出版。

她嫁給了一位著名的德國管風琴家，所以她喜歡管風琴音樂並對管風琴瞭若指掌，也就不足為奇了。她所有書的第一批讀者總是她的三個孩子。

Ksenia Bönig studied graphic design and illustration at the Communication Design Academy of Cologne in Germany. While still a student, she began writing and illustrating books for children, which have since been published in 7 languages around the world.

She is married to a well-known German organist, so it is not surprising that she loves organ music and knows a lot about the organ. The first readers of all her books are always her three children.

Origin 27

打開管風琴的祕密

文、圖／西妮雅・博尼希 ｜ 審閱／耿一偉、劉信宏
責任編輯／廖宜家 ｜ 主編／謝翠鈺 ｜ 企劃／陳玟利
美術編輯、封面設計／SHRTING WU ｜ 董事長／趙政岷
出版者／時報文化出版企業股份有限公司
108019台北市和平西路三段240號七樓
發行專線／（02）2306-6842
讀者服務專線／0800-231-705、（02）2304-7103
讀者服務傳真／（02）2304-6858
郵撥／1934-4724時報文化出版公司
信箱／10899臺北華江橋郵局第99信箱
時報悅讀網／www.readingtimes.com.tw
法律顧問／理律法律事務所 陳長文律師、李念祖律師

合作出版／國家表演藝術中心衛武營國家藝術文化中心
中文翻譯協力／琴峰（樂器）企業股份有限公司（德國克萊斯管風琴臺灣代理）
特別感謝／德國克萊斯管風琴

印刷／和楹印刷有限公司
初版一刷／2022年3月18日 ｜ 定價／新台幣320元
初版三刷／2023年11月01日
缺頁或破損的書，請寄回更換
版權所有，請勿翻印
版權 © 2015 Ksenia Bönig
Printed in Taiwan／ISBN 978-626-335-138-7

GREAT BIG BOOK ABOUT THE PIPE ORGAN
Text, Illustration by Ksenia Bönig
Mandarin Proofreading by Hsin-Hung Liu and Yi-Wei Keng
Co-published by National Performing Arts Center-National Kaohsiung Center for the Arts (Weiwuying)

Mandarin translation assisted by Musicpro Corporation, Taipei, Taiwan
Special thanks to Orgelbau Klais Bonn, Germany

時報文化出版公司成立於一九七五年，並於一九九九年股票上櫃公開發行，
於二〇〇八年脫離中時集團非屬旺中，以「尊重智慧與創意的文化事業」為信念。